Coloring for the Calm Mom

welcome to BABY LAND

MAGGIE LORD

illustrated by KATHRYN HOLEMAN

Little, Brown and Company

New York Boston London

Also by Maggie Lord and Kathryn Holeman

Color Me Married

Little, Brown and Company
Hachette Book Group
1290 Avenue of the Americas, New York NY 10104
littlebrown.com

First Edition: September 2016

Little, Brown and Company is a division of Hachette Book Group, Inc. The Little, Brown name and logo are trademarks of Hachette Book Group, Inc.

The publisher is not responsible for websites (or their content) that are not owned by the publisher.

The Hachette Speakers Bureau provides a wide range of authors for speaking events. To find out more, go to hachettespeakersbureau.com or call (866) 376-6591.

ISBN 978-0-316-36293-1
Library of Congress Control Number: 2016943910

10 9 8 7 6 5 4 3 2 1

WW

Printed in the United States of America

Maggie Lord is the founder of the popular blogs RusticWeddingChic.com and RusticBabyChic.com. With millions of readers monthly, Maggie has become a sought-after wedding and lifestyle expert who shares her tips and insights regularly on both TV and in a variety of publications, including the *New York Times,* the *Huffington Post, Fast Company,* and others. Maggie is the author of four other books, including the popular adult coloring book *Color Me Married.* Maggie lives in Connecticut with her husband, the writer Jonathan Lord, and their two young sons.

Carrying her drawing pens and paper everywhere she goes, **Kathryn Holeman** loves to sketch the beauty and magic she sees in her everyday world. Kathryn studied illustration and print-making at Ohio Wesleyan University and is the owner and principal designer at KSH Creative. She lives outside of Philadelphia with her husband and two sons. You can find more of her work at kshcreative.com.

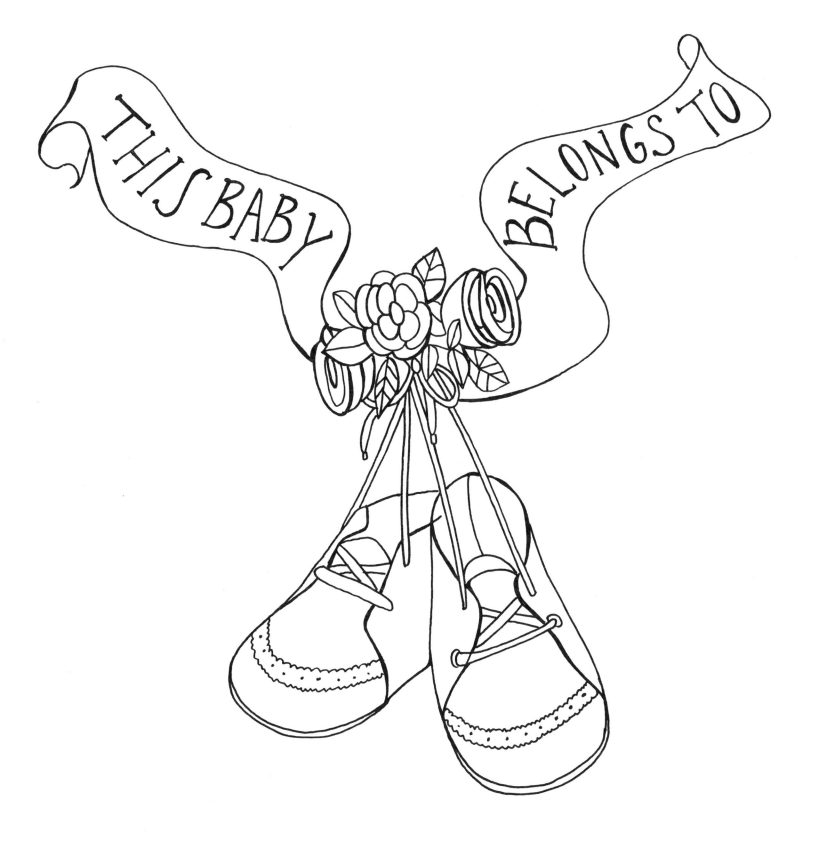

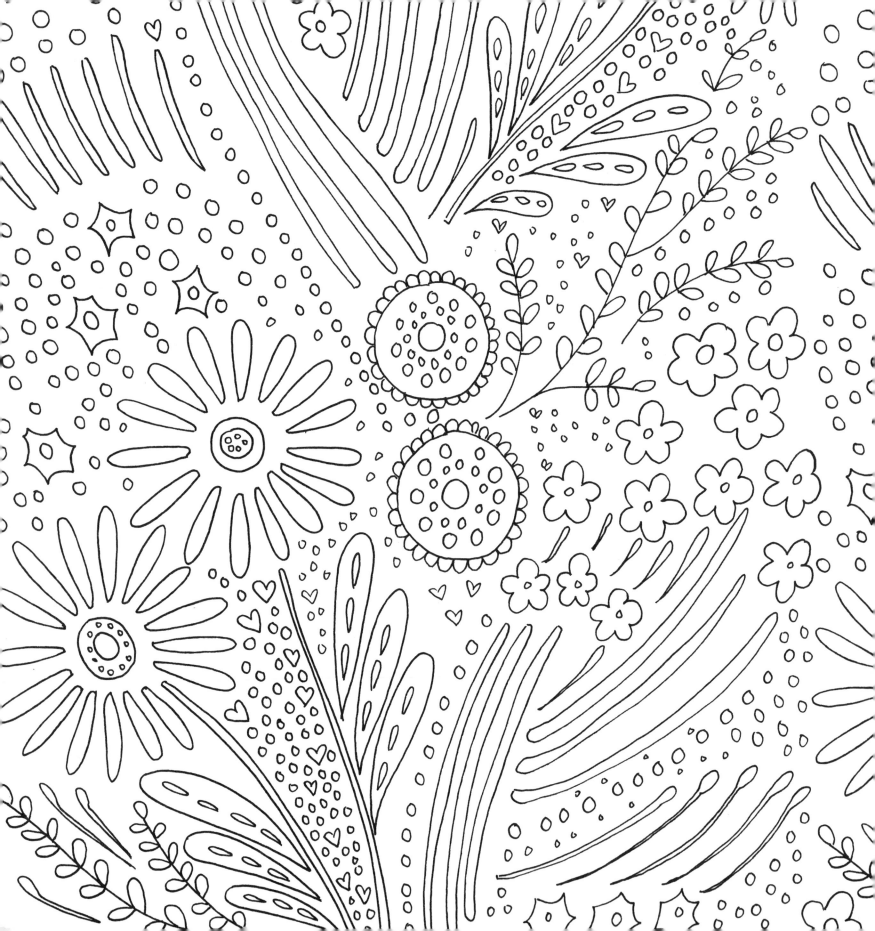

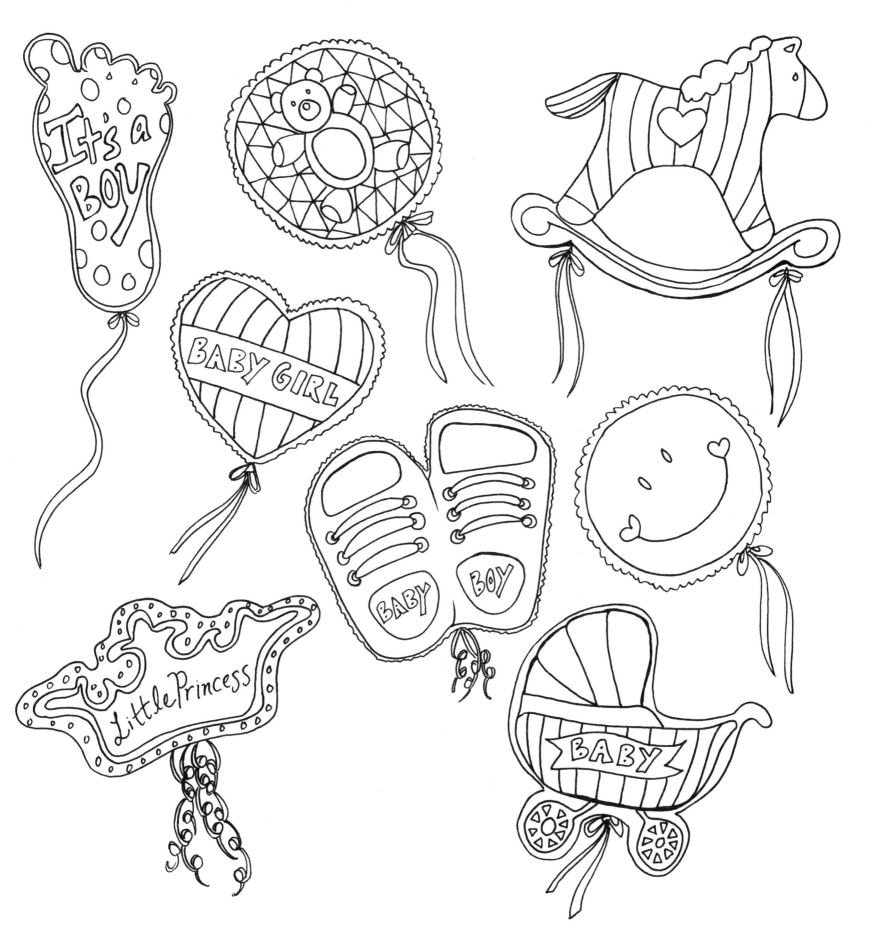

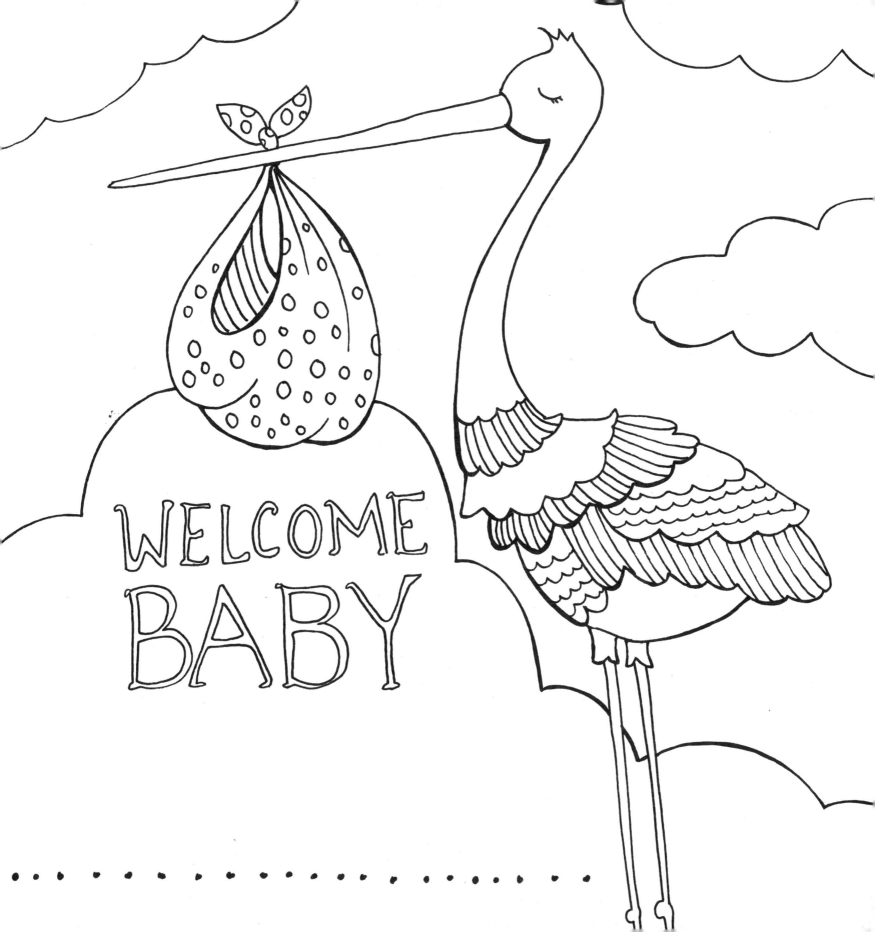

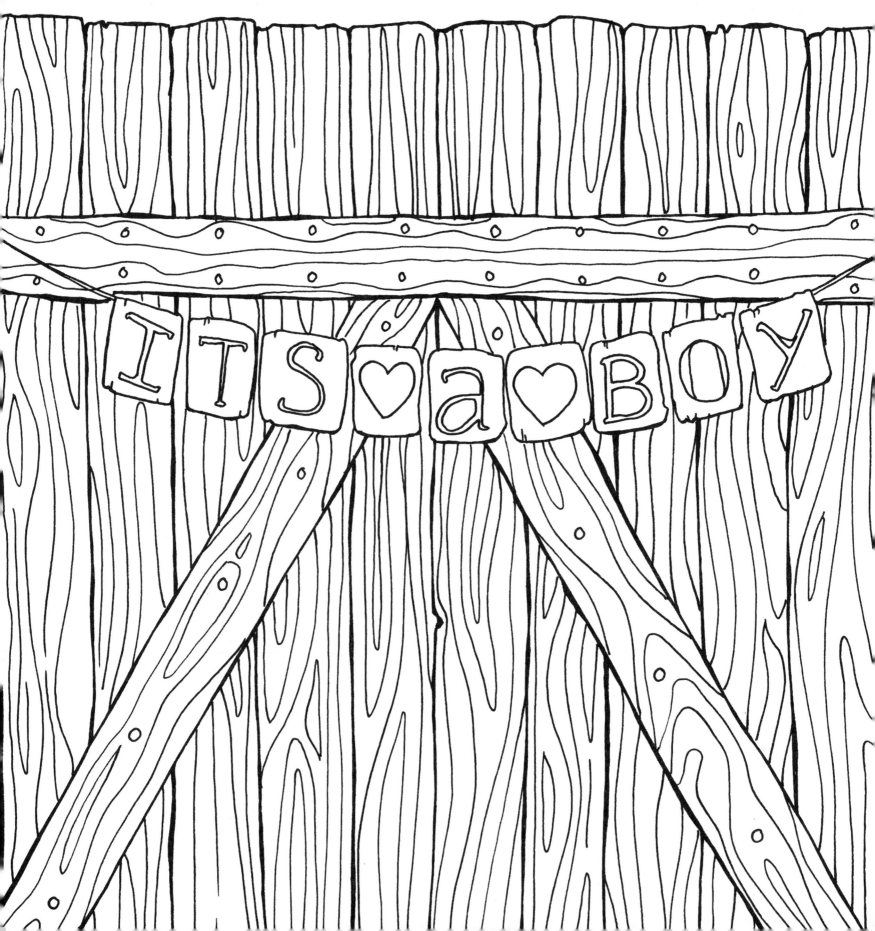

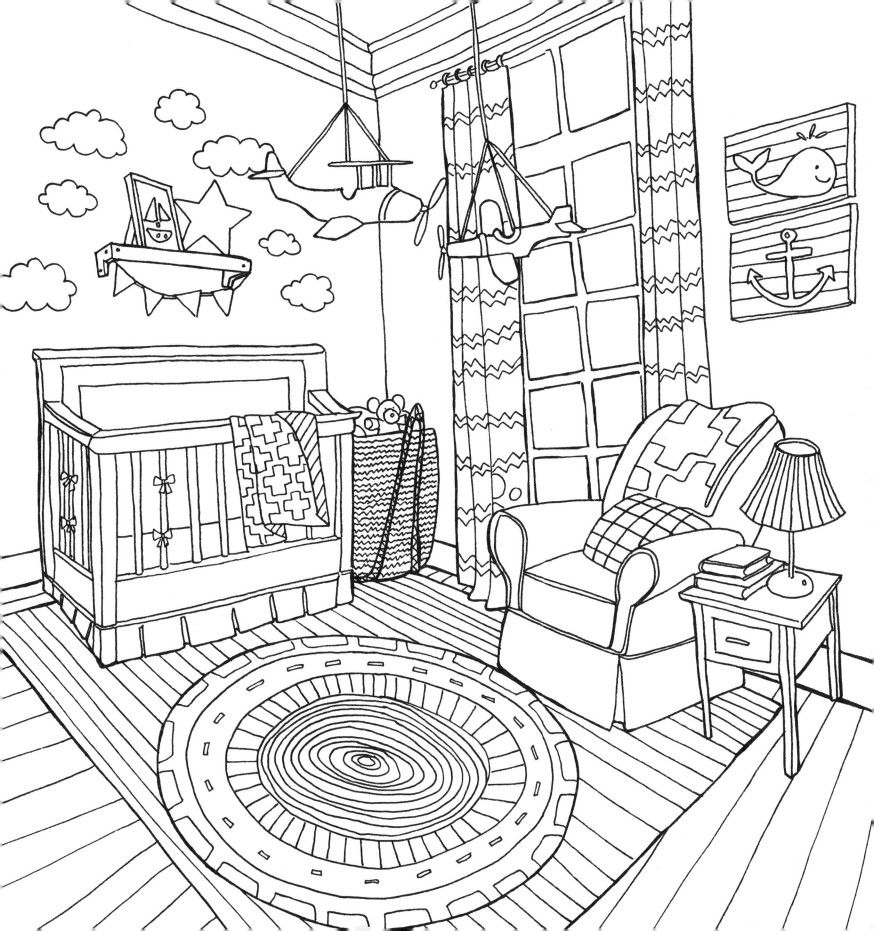

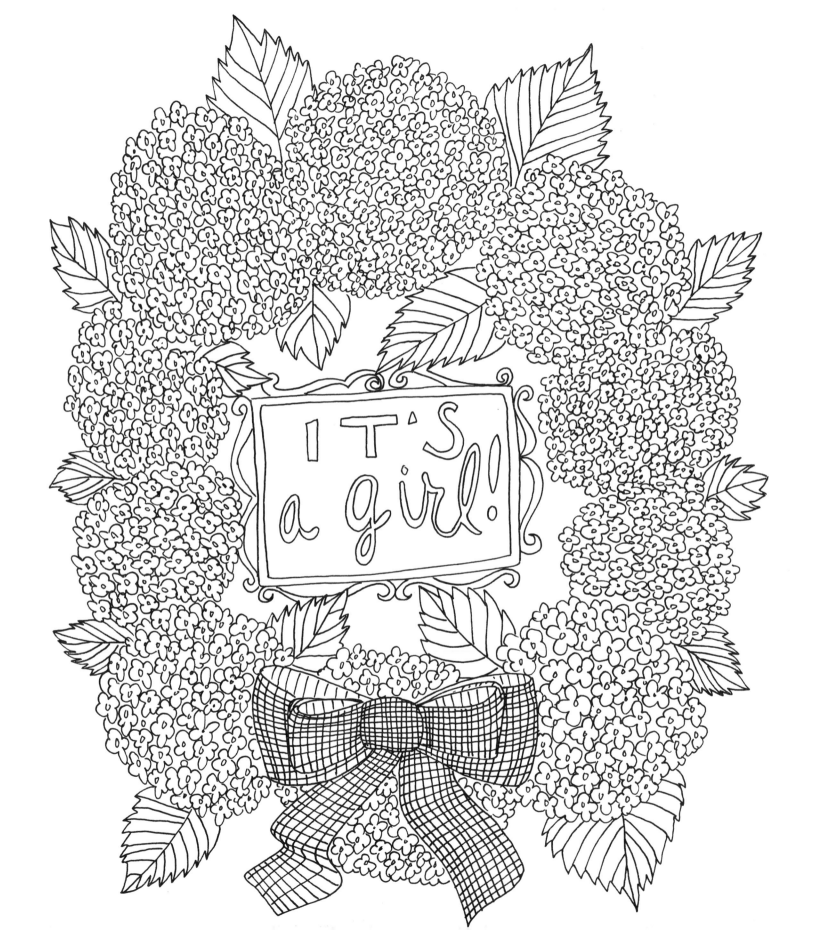

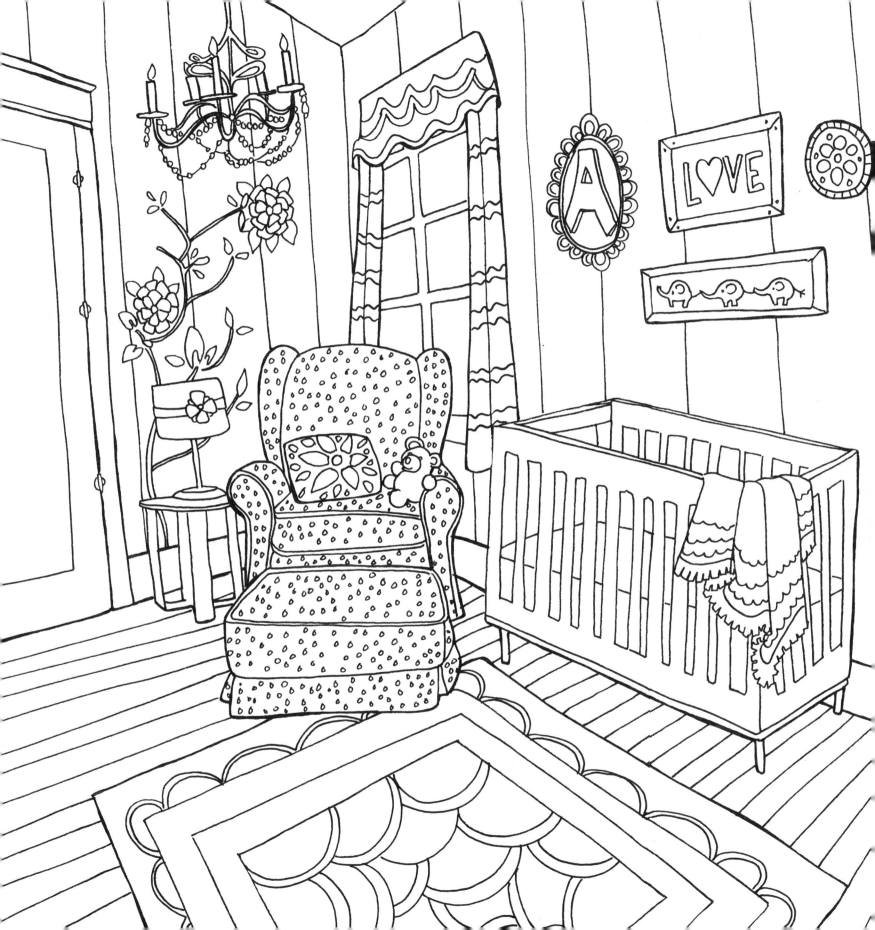

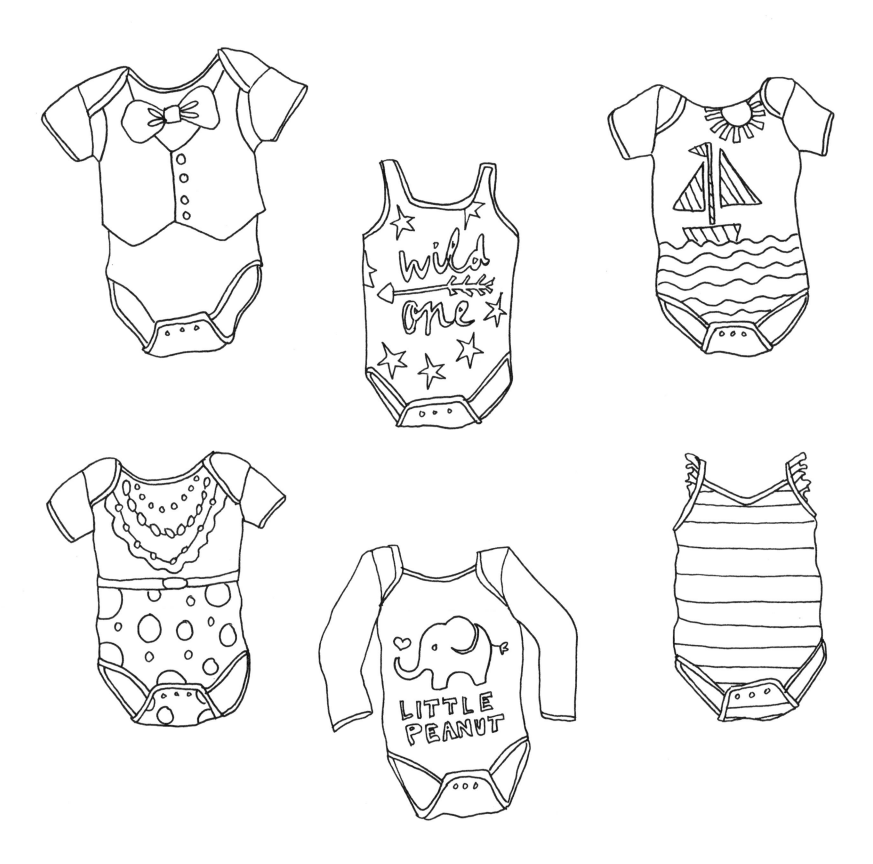

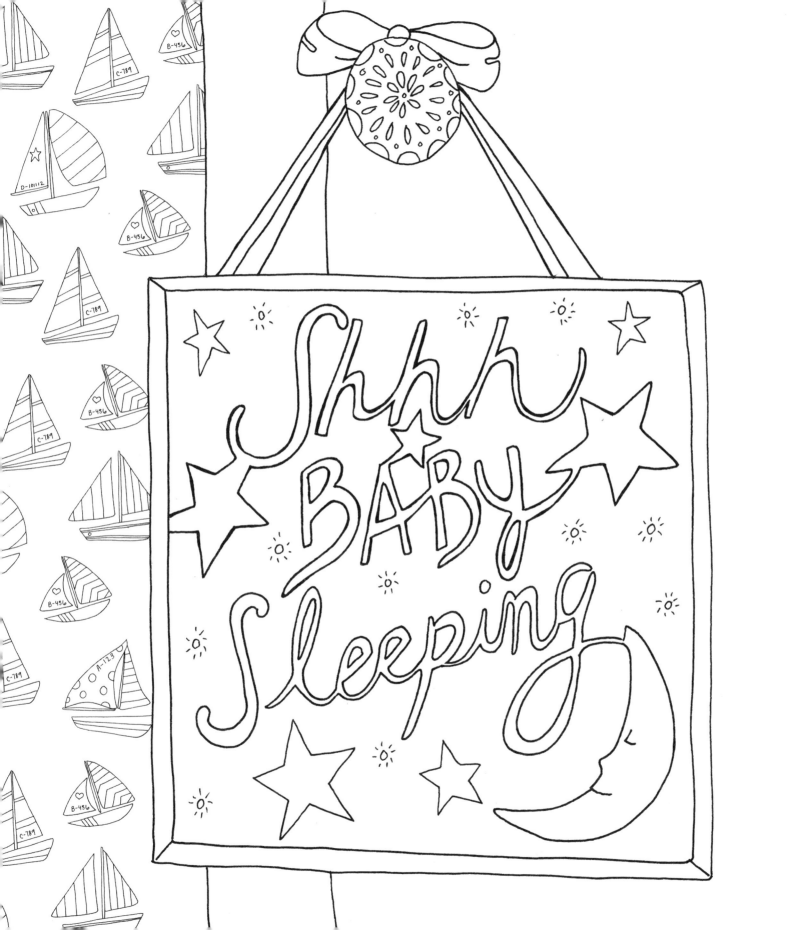

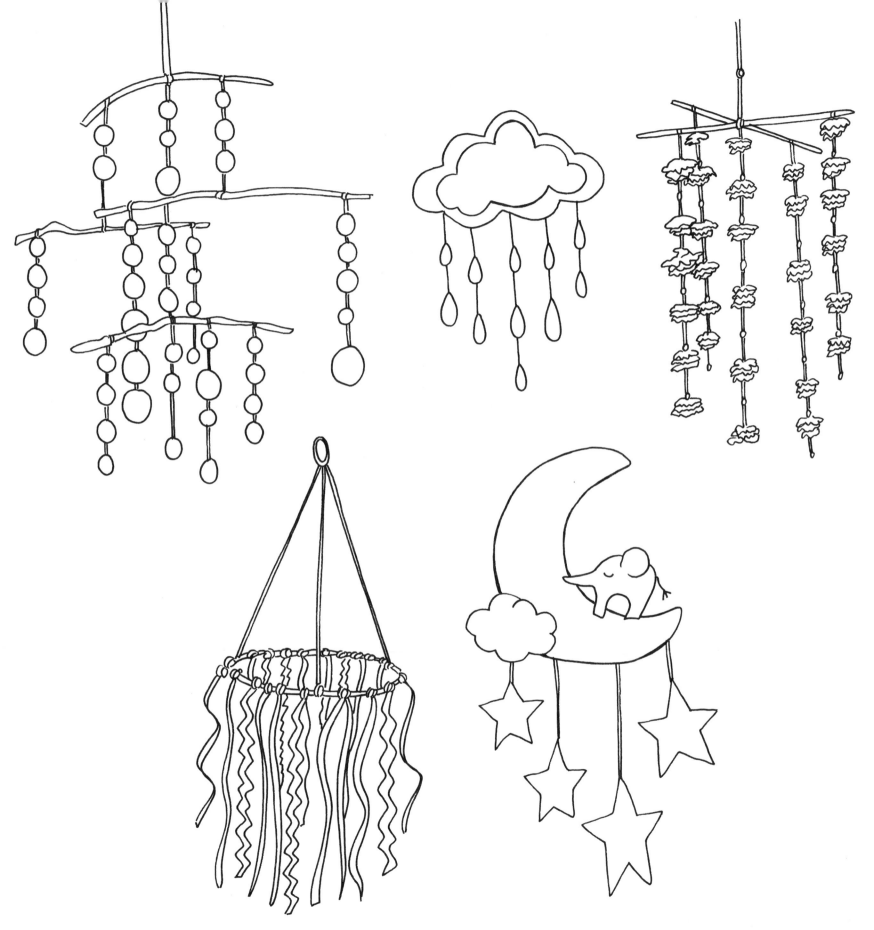

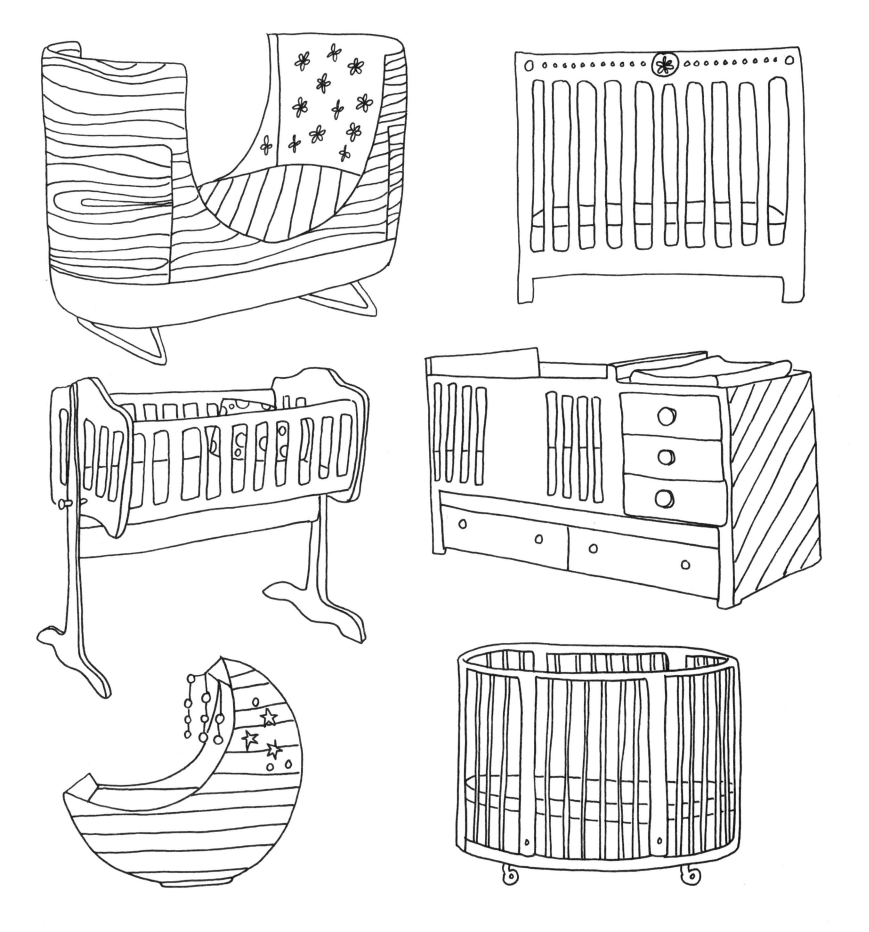

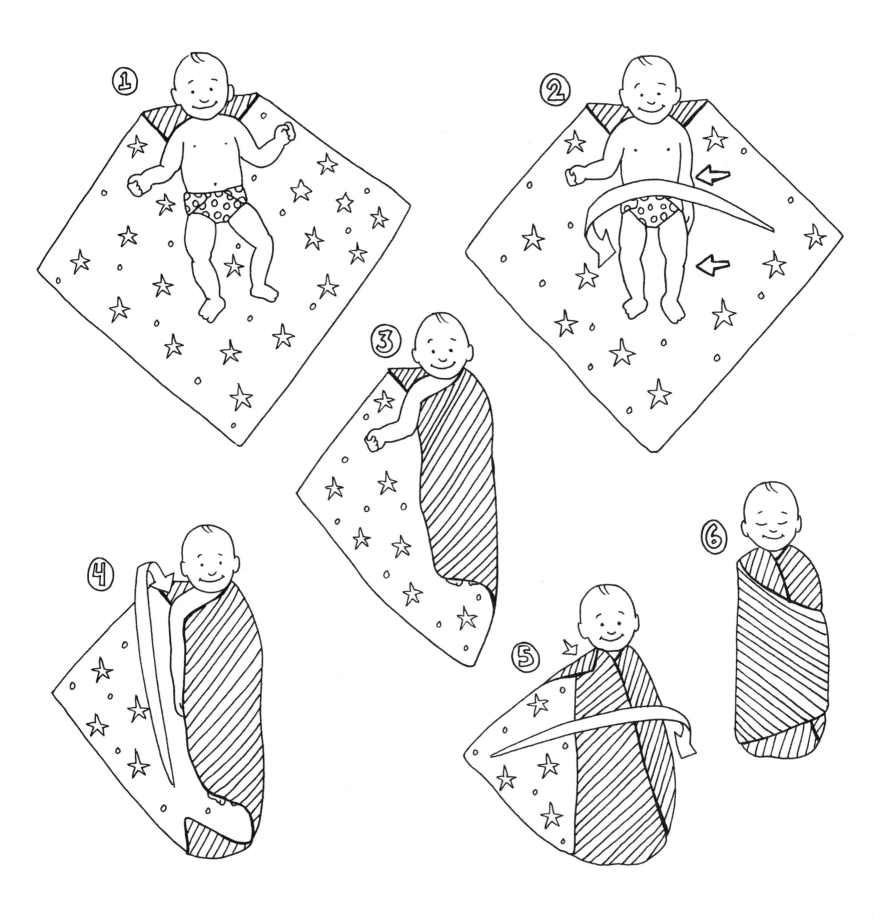

MADRE y PADRE

MOM

Mommy

daddy

dada DAD

♡

MAMA mere et pere

NANA GRANDAD
POP NANNY
POPPA MIMI
GRAMMY GRAMPS
GRANDMA POPS

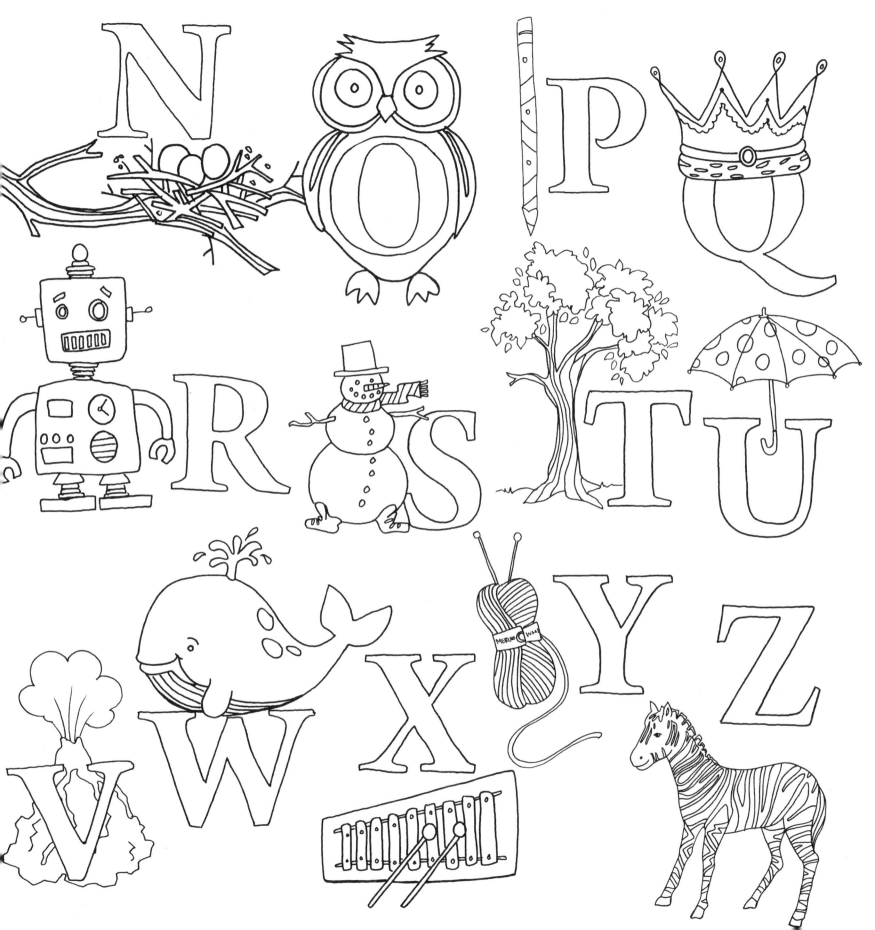

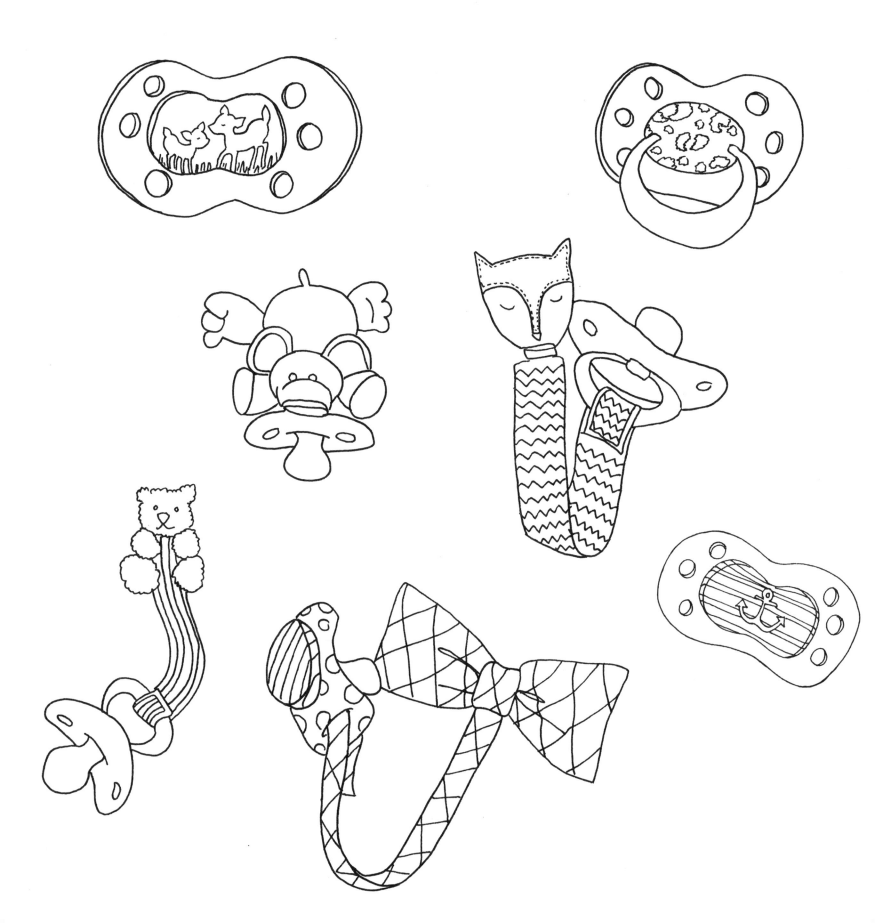

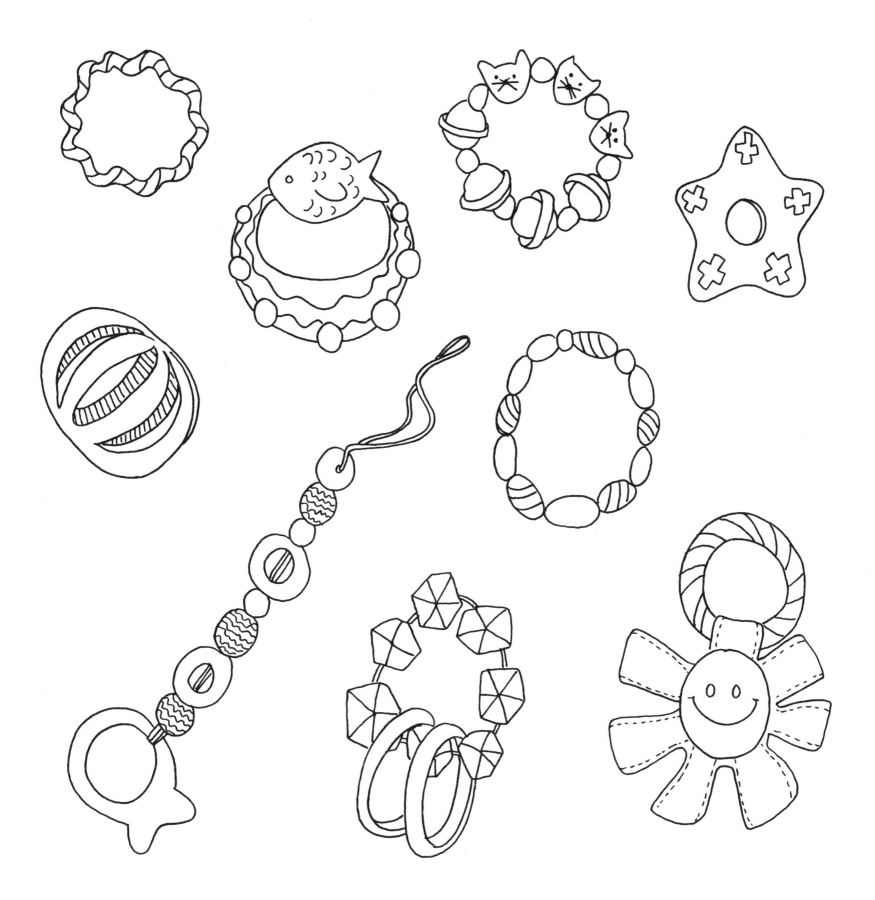

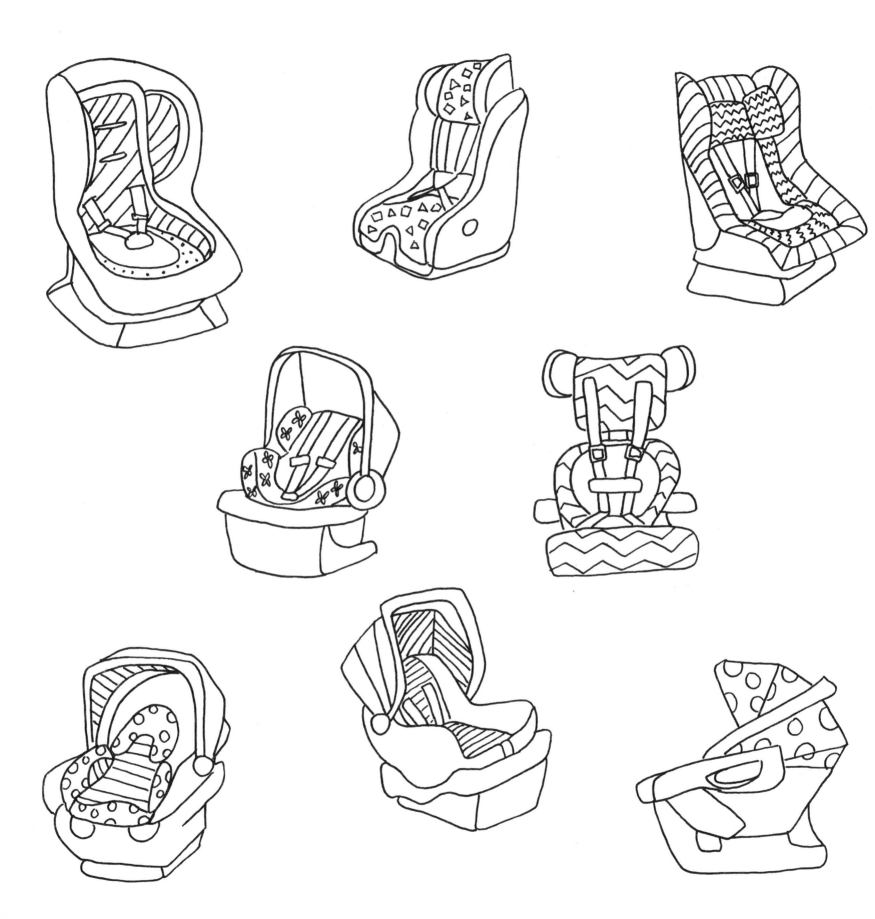

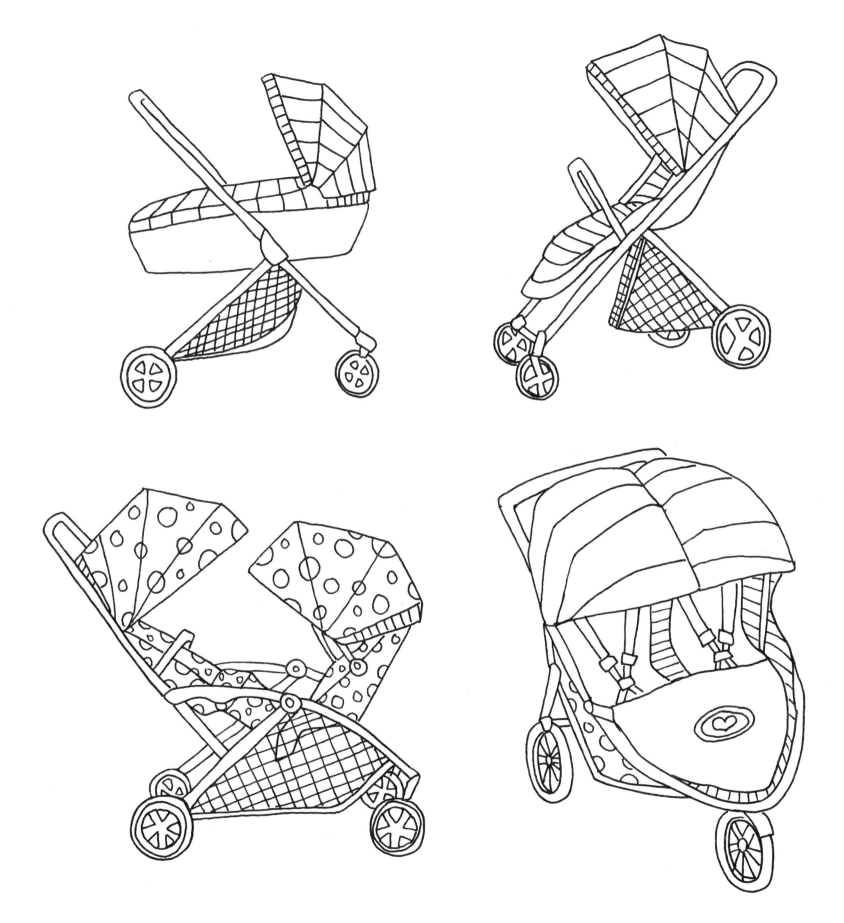

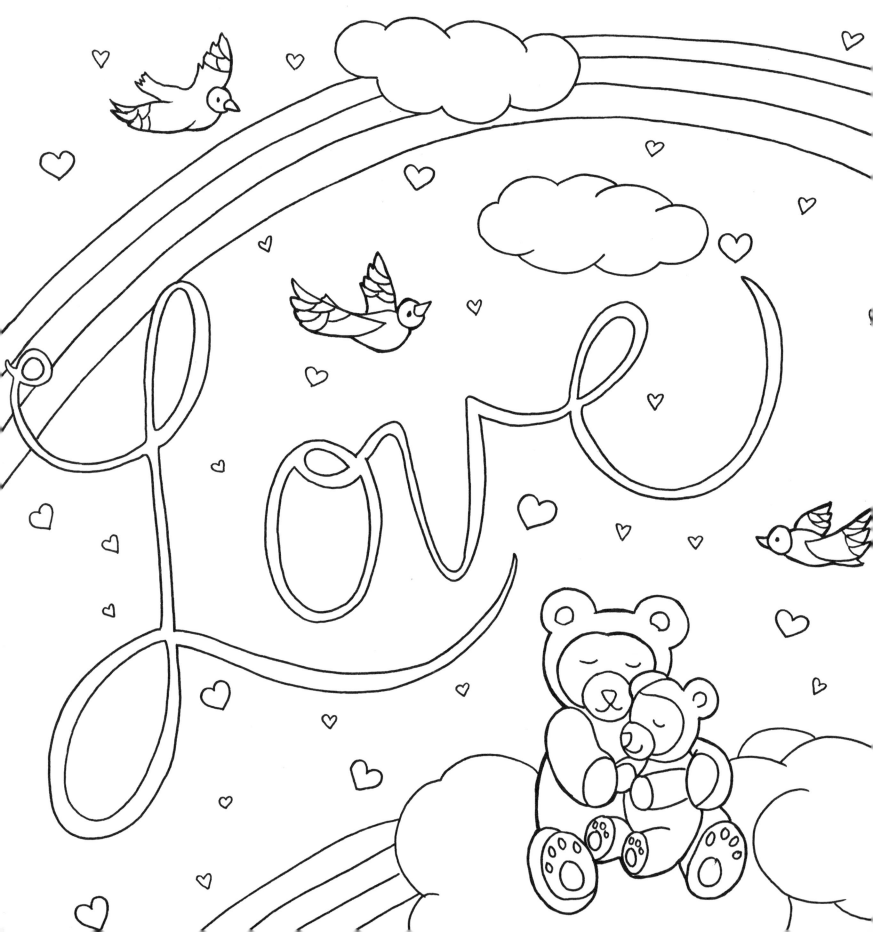

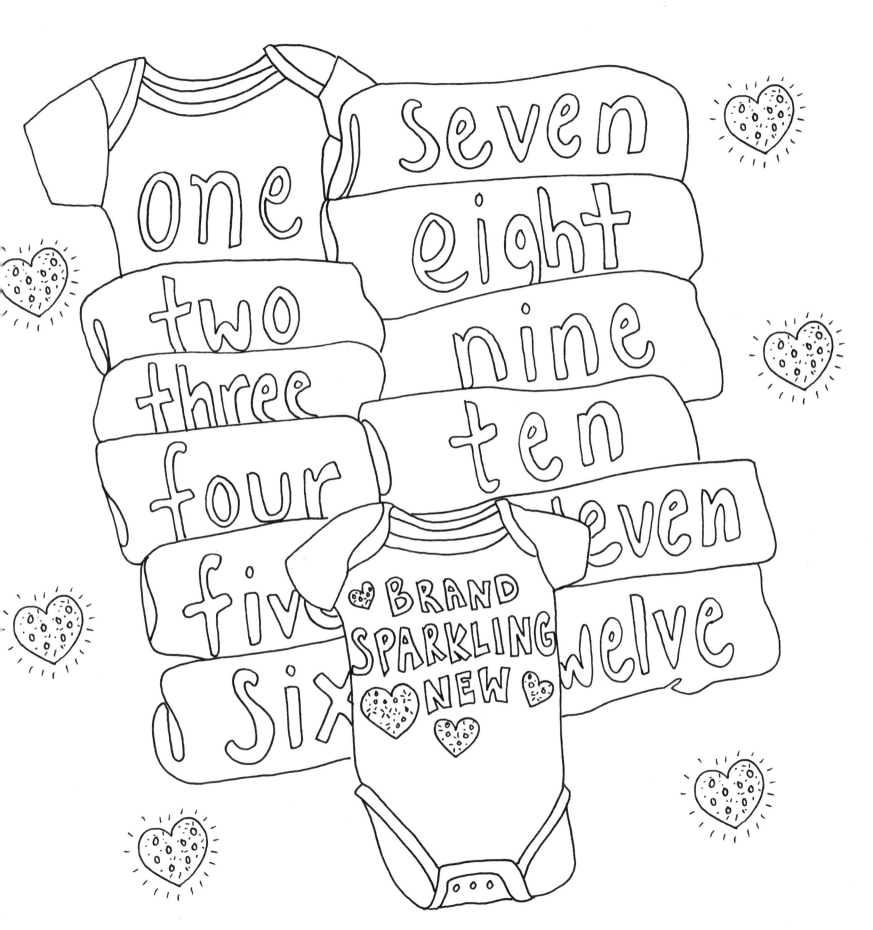

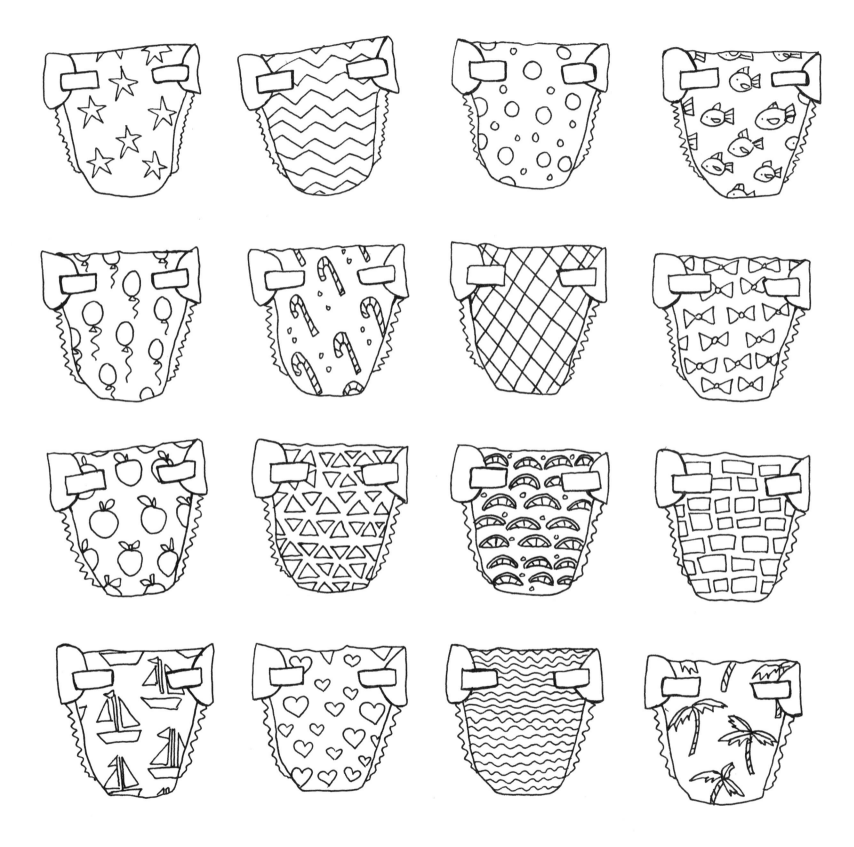

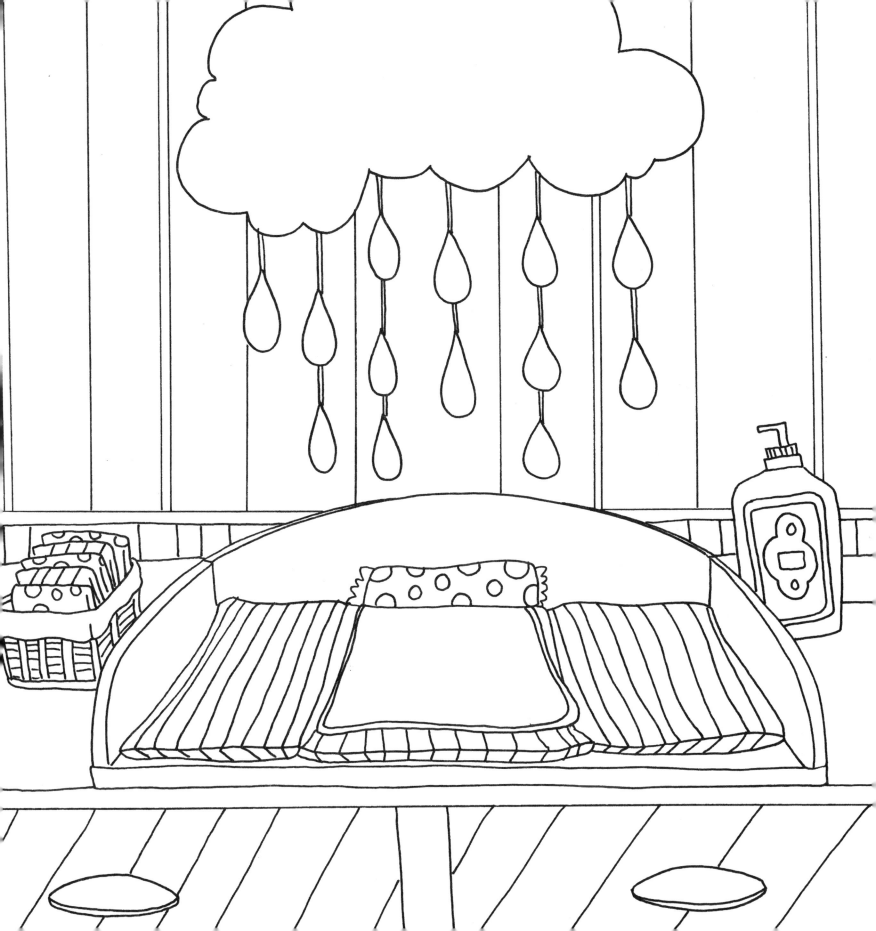

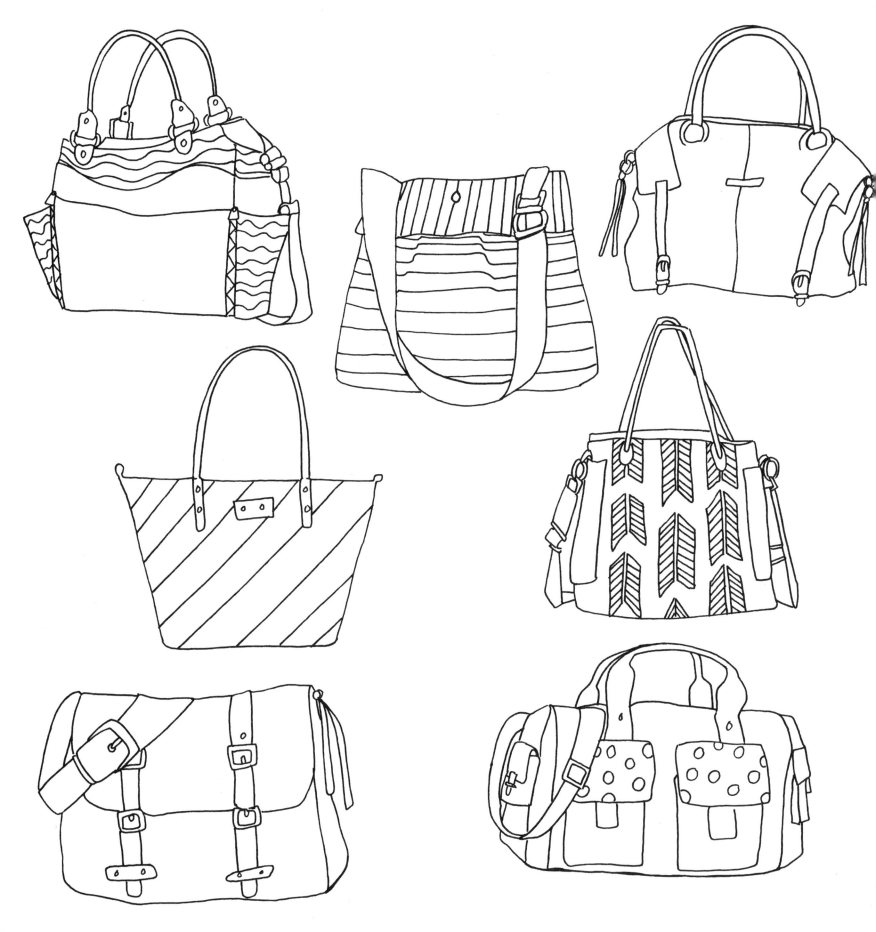

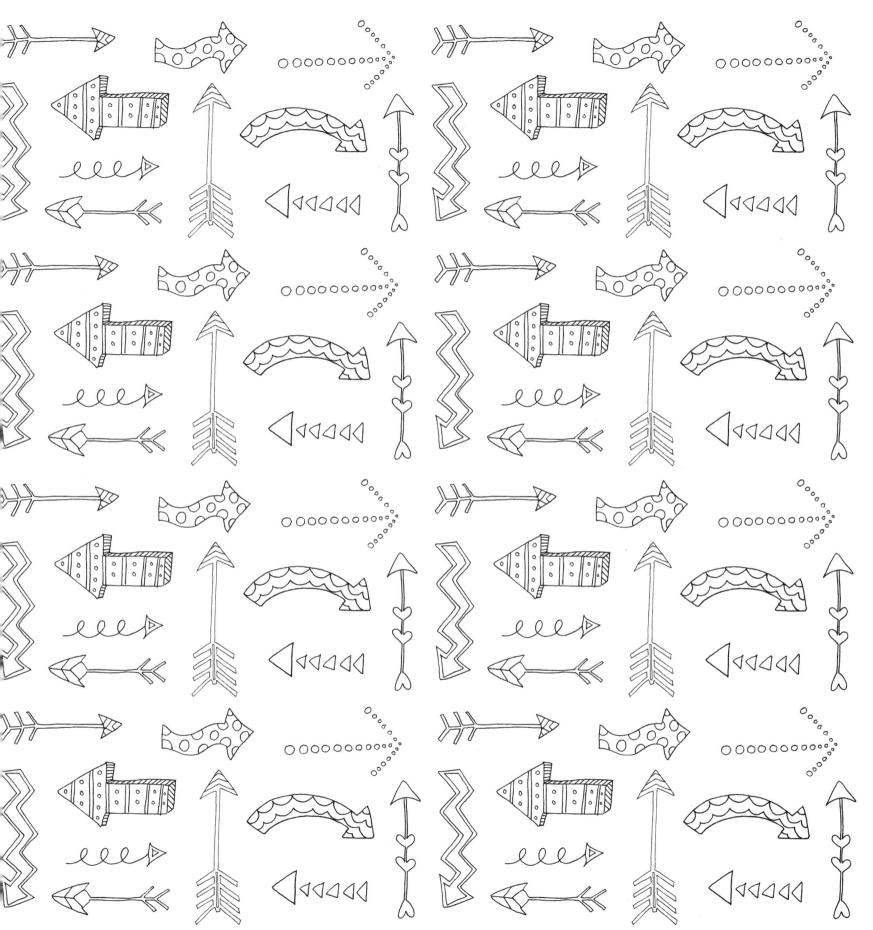

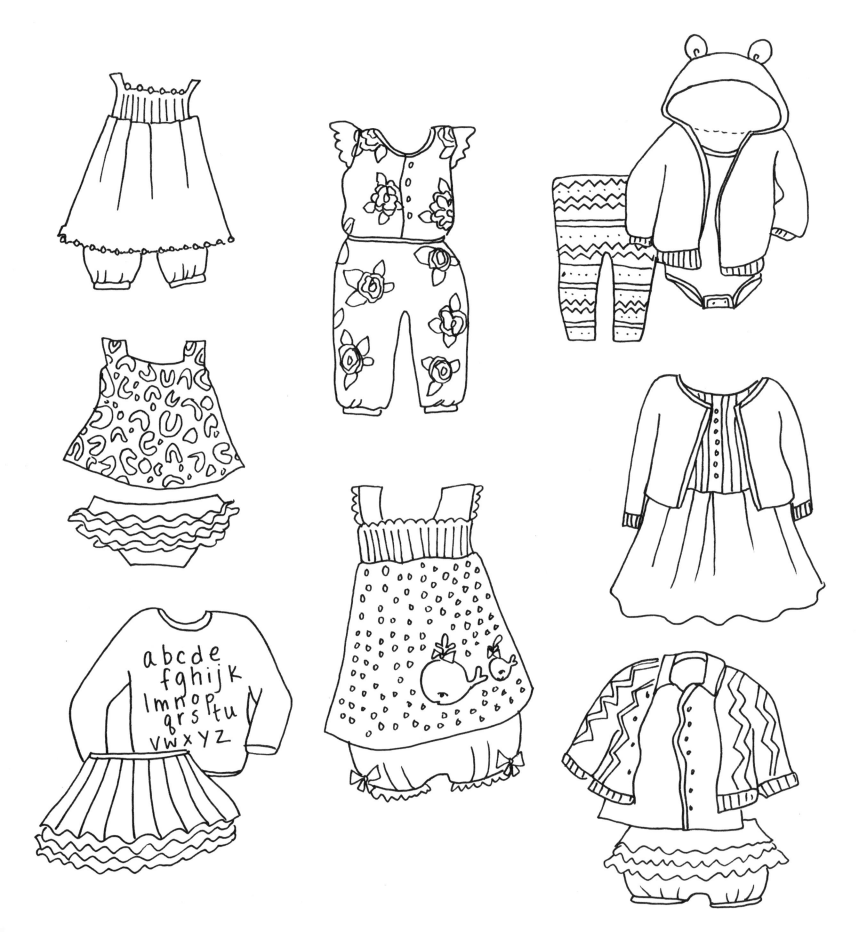

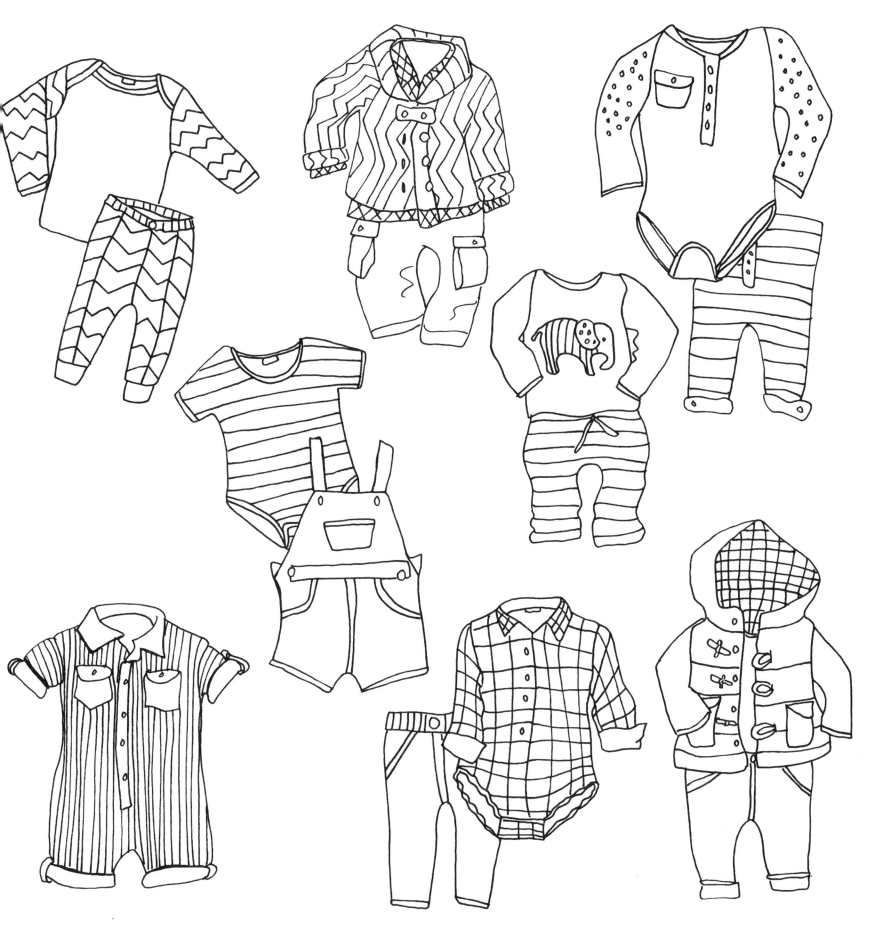

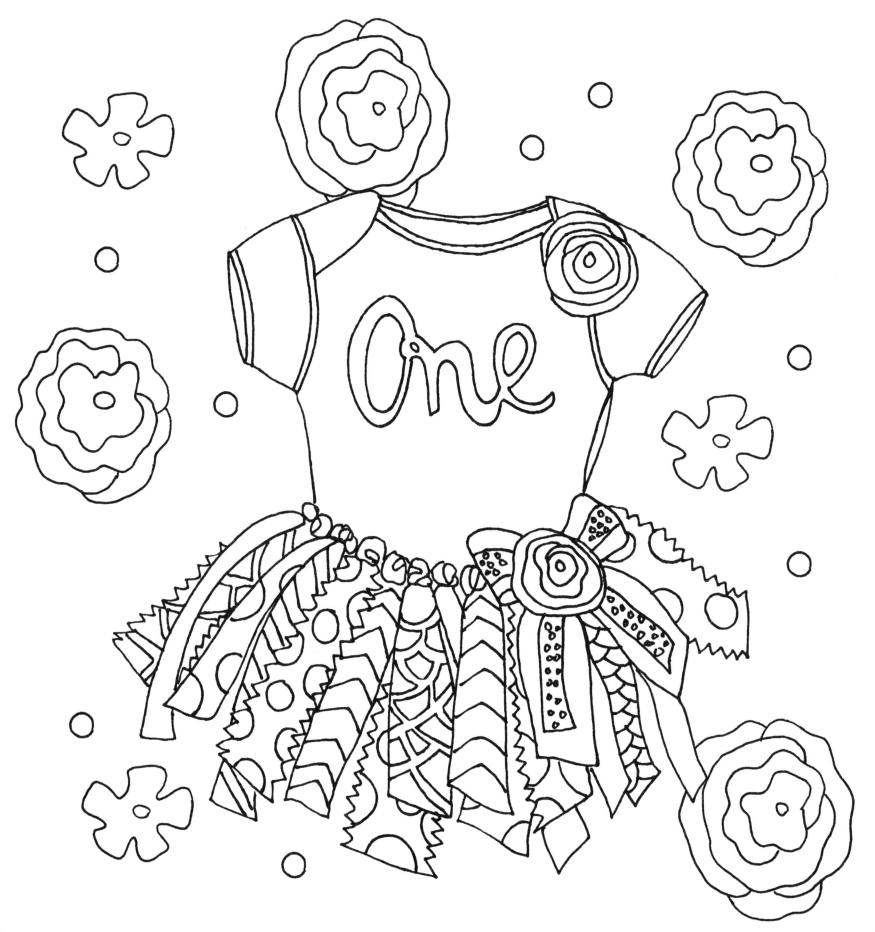

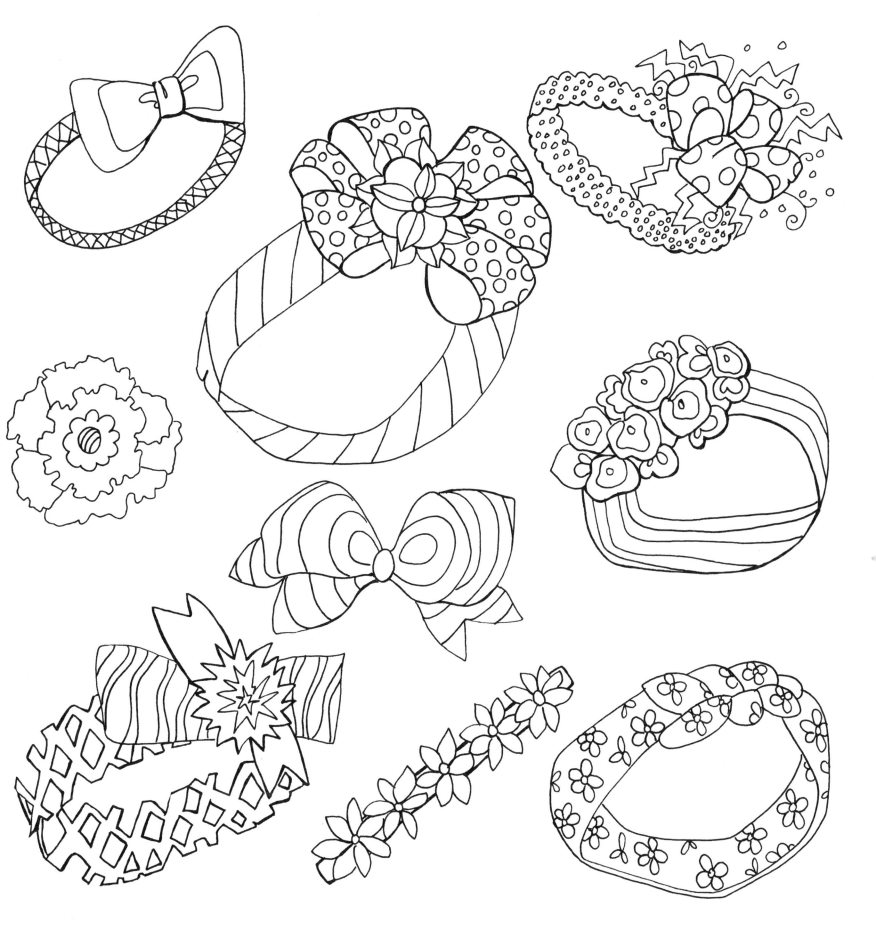

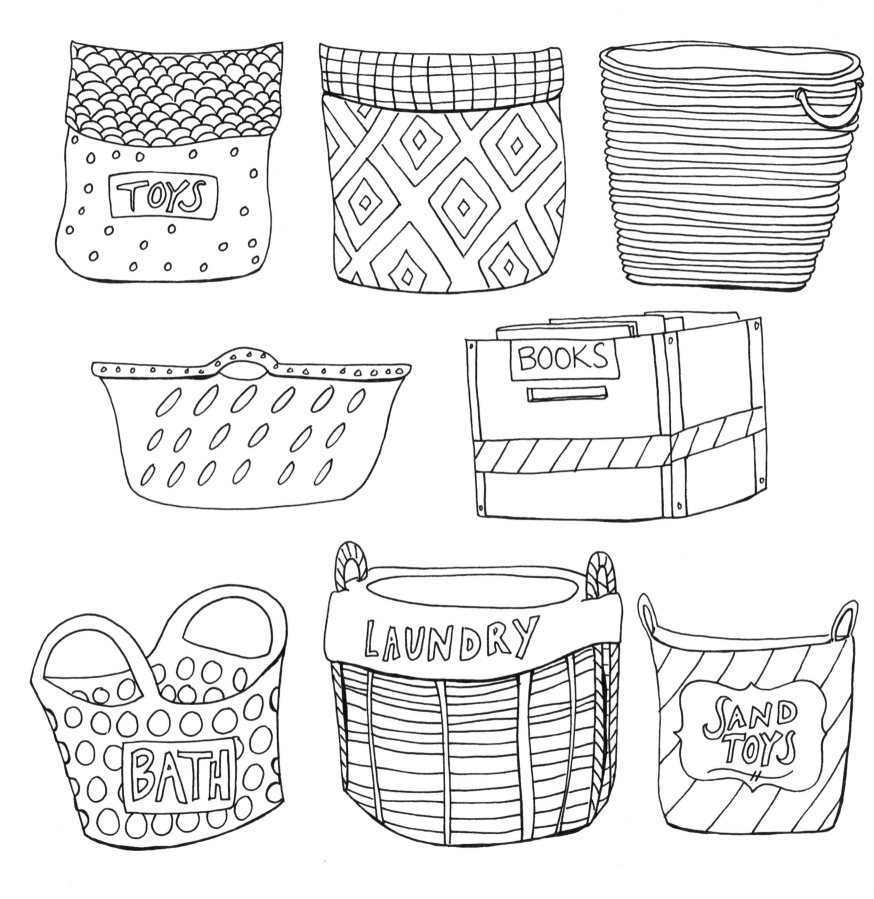

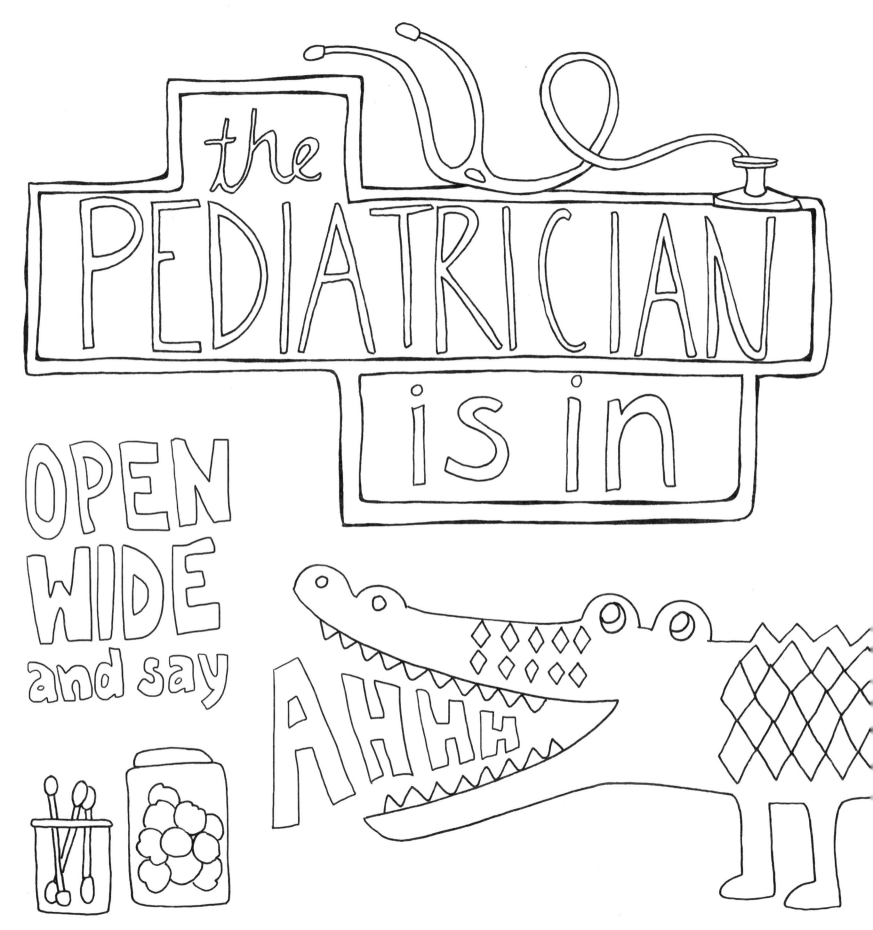

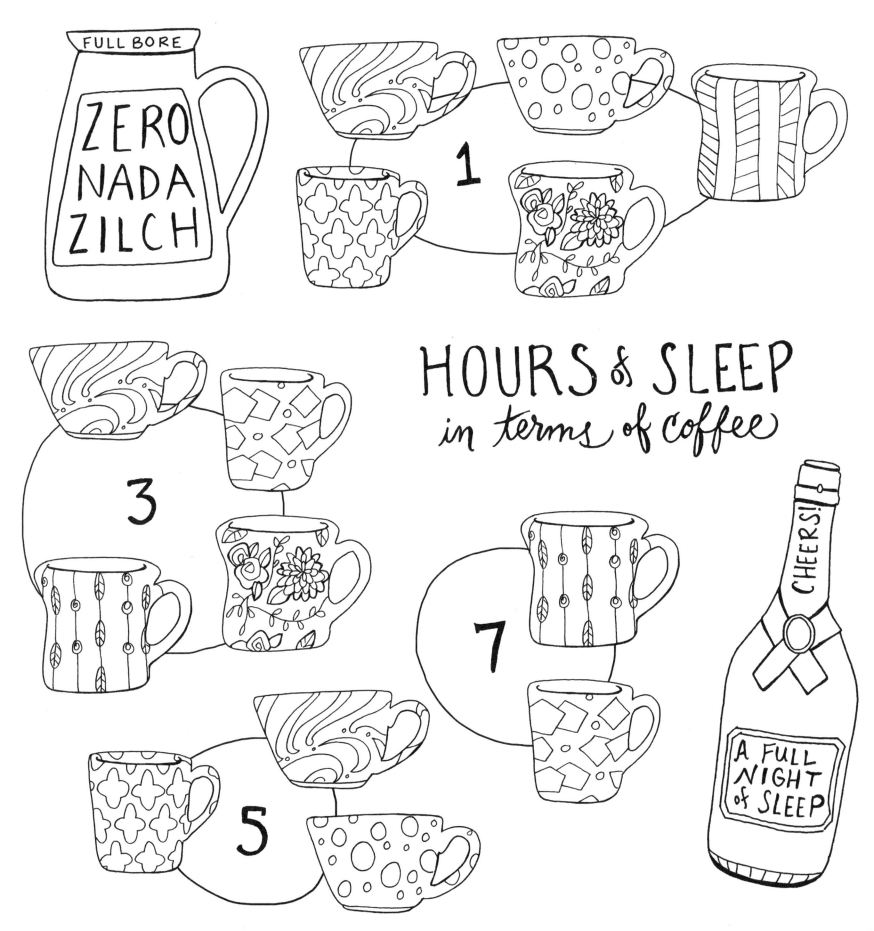

FULL BORE

ZERO NADA ZILCH

1

HOURS of SLEEP
in terms of coffee

3

7

5

CHEERS!

A FULL NIGHT of SLEEP

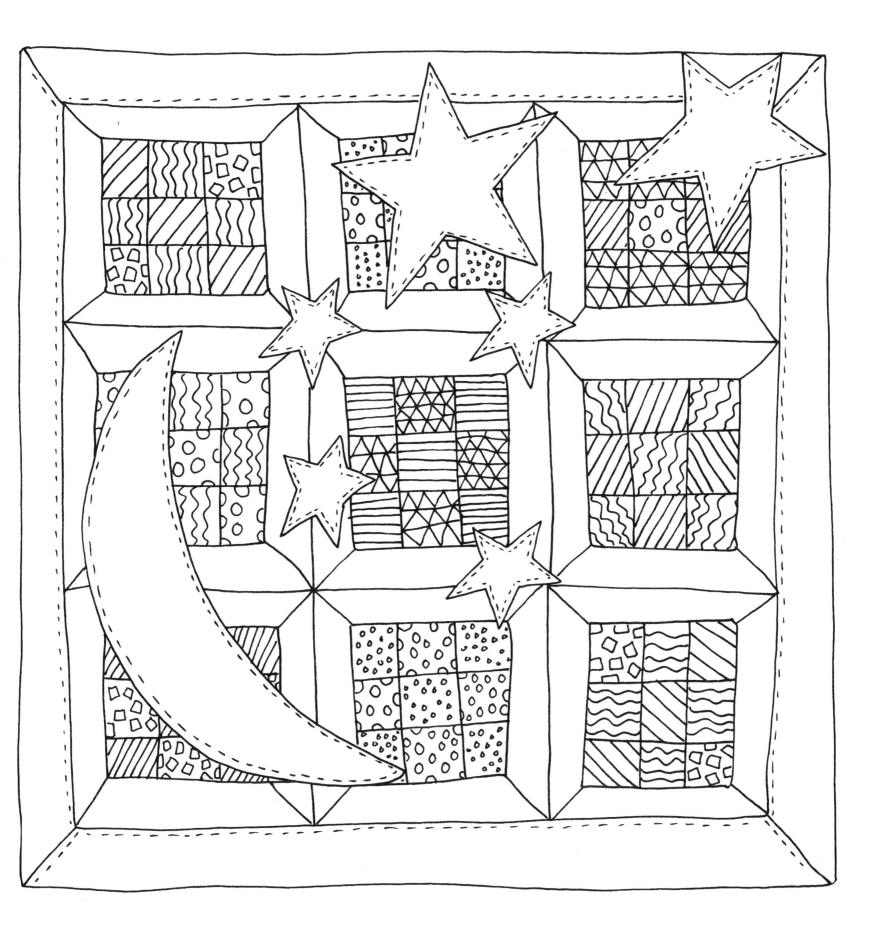

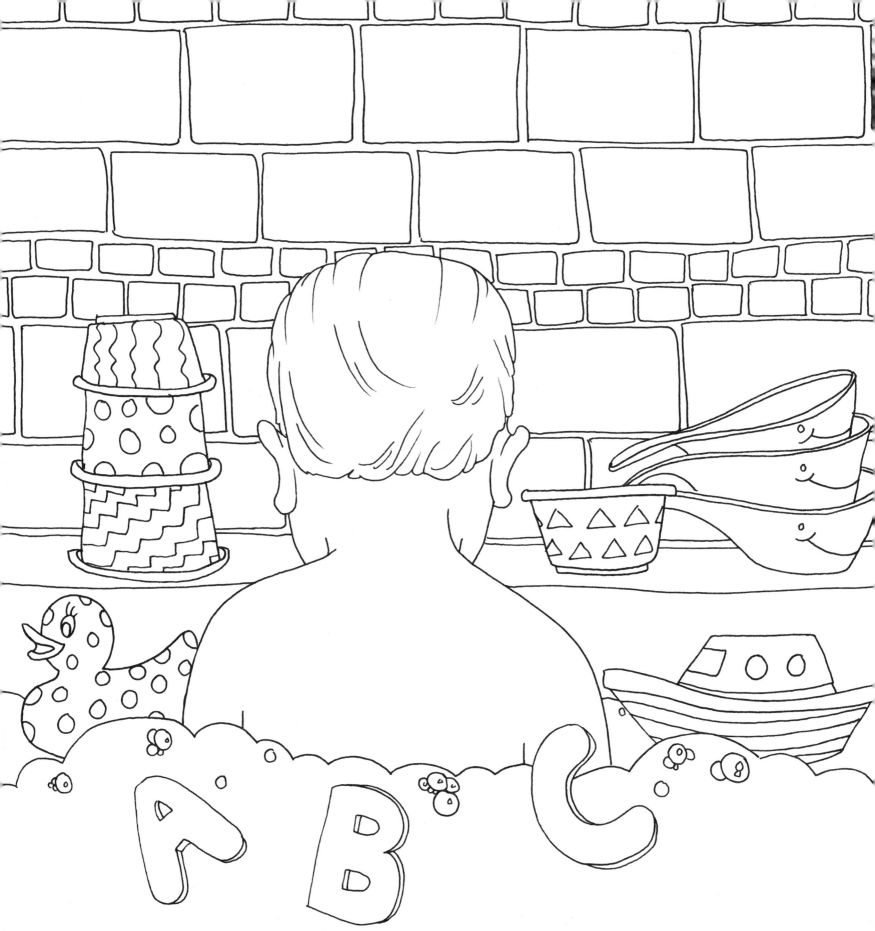

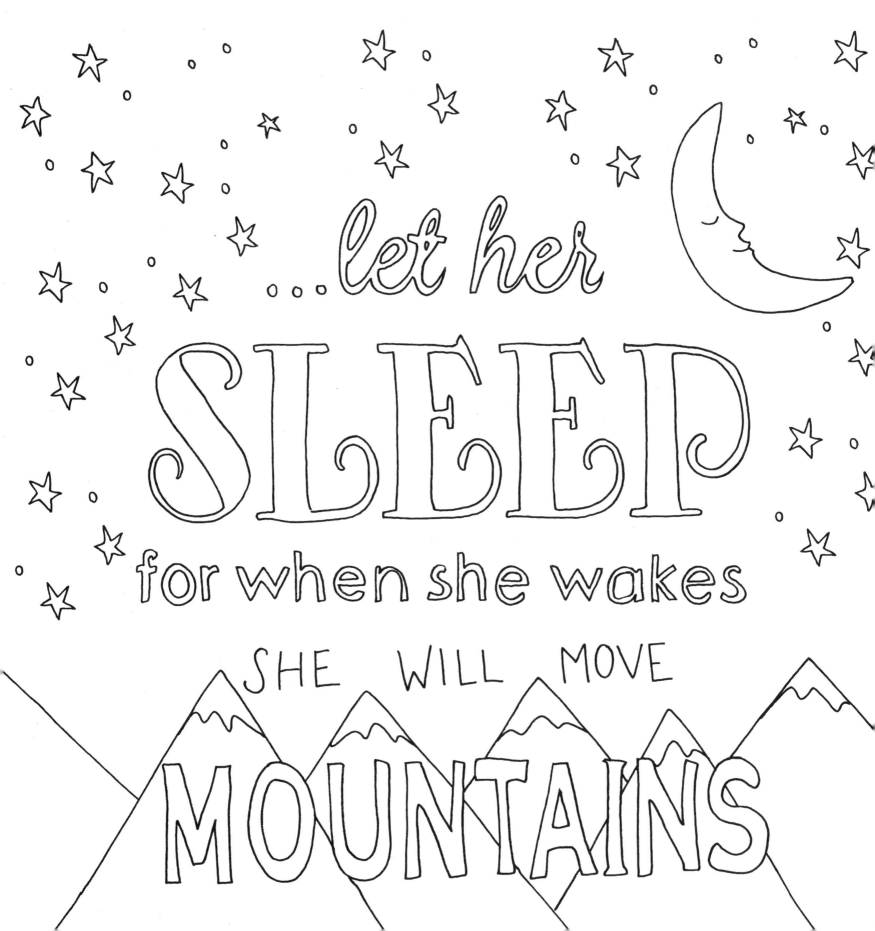

i can TOTALLY function on 2 HOURS of SLEEP

SHOULD I CALL MY MOTHER NOW?

I WILL WEAR MY YOGA PANTS YET NO YOGA will be done.

seriously, another? DIRTY DIAPER?

SHOULD WE CALL THE DOCTOR?

when all else fails CALL GRANDMA!

did you hear a baby cry?

THIS CUP BELONGS TO:

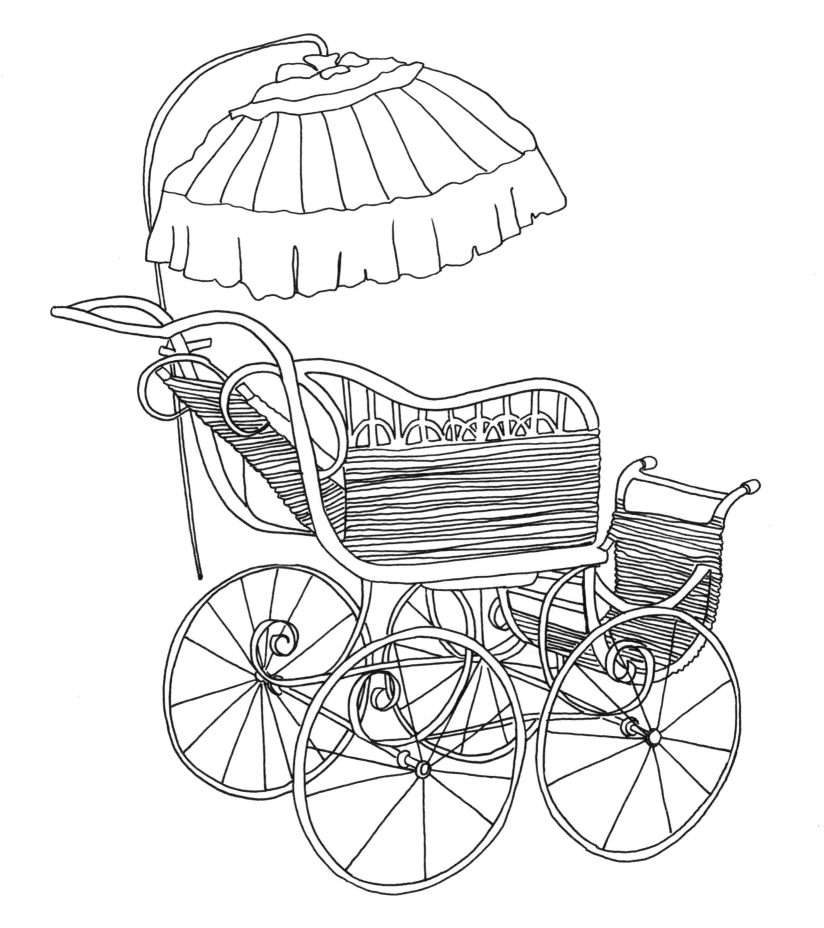

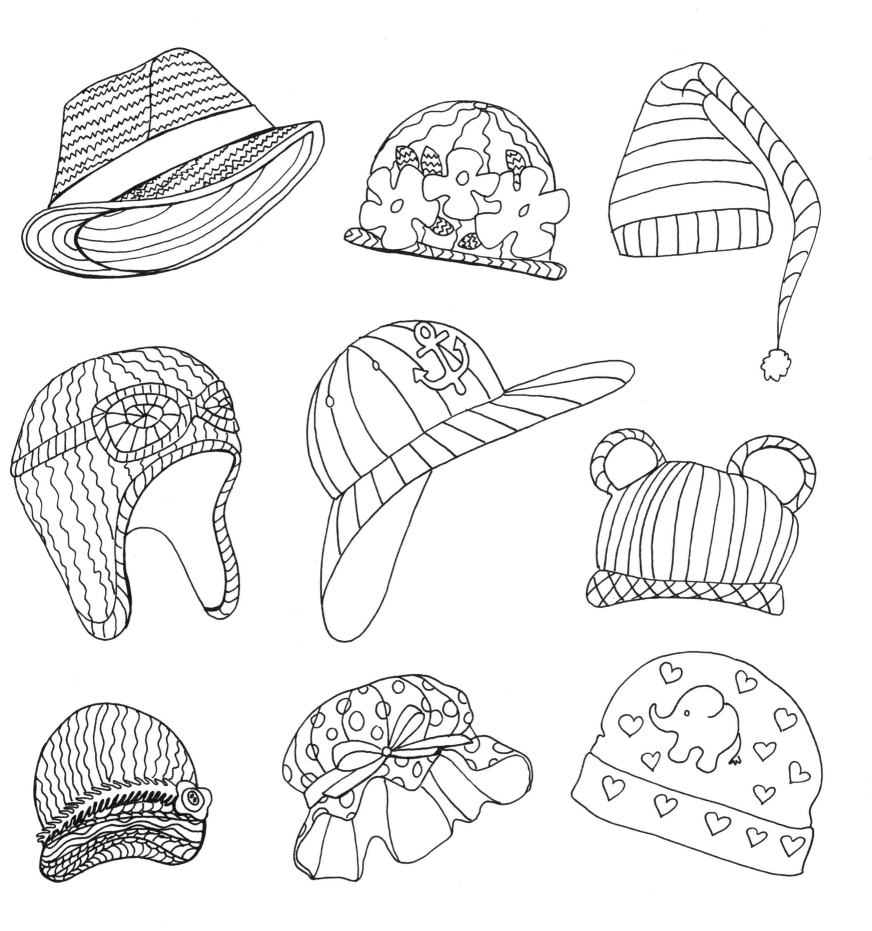

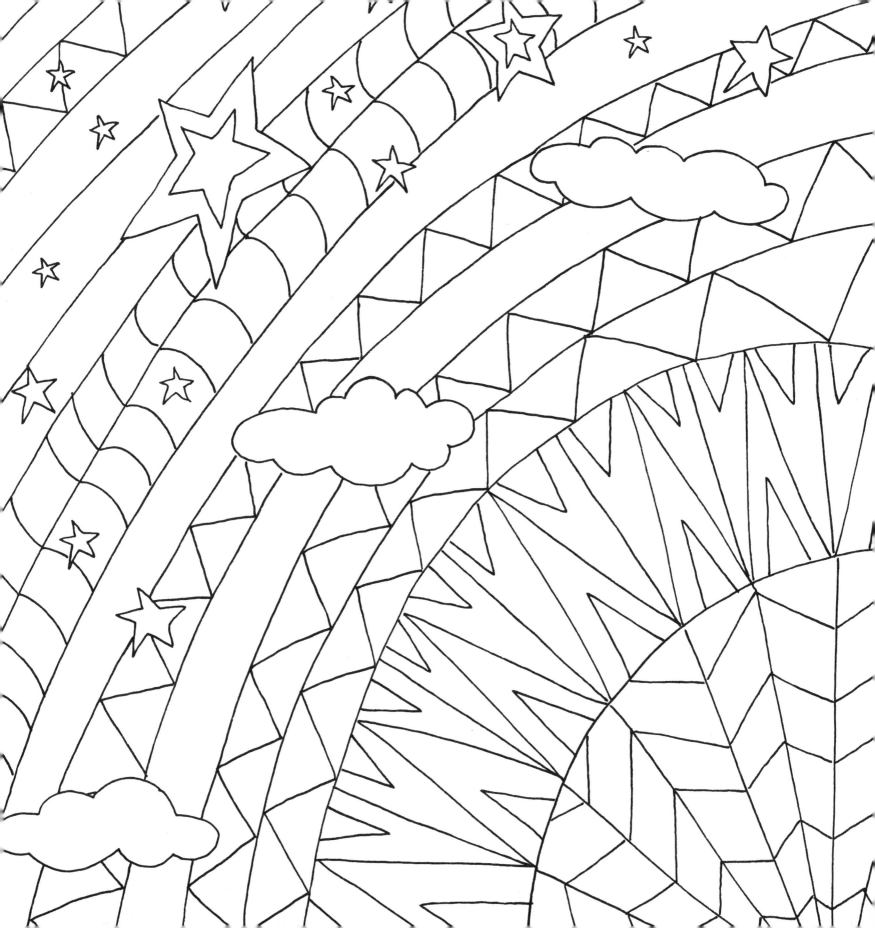

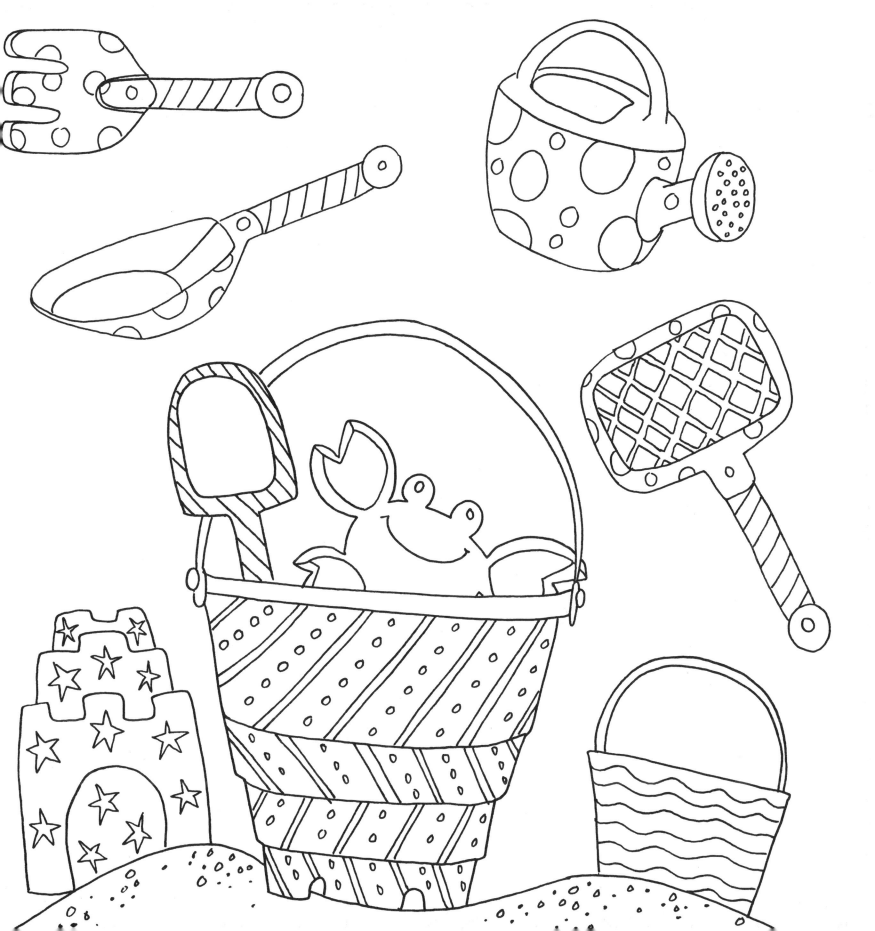

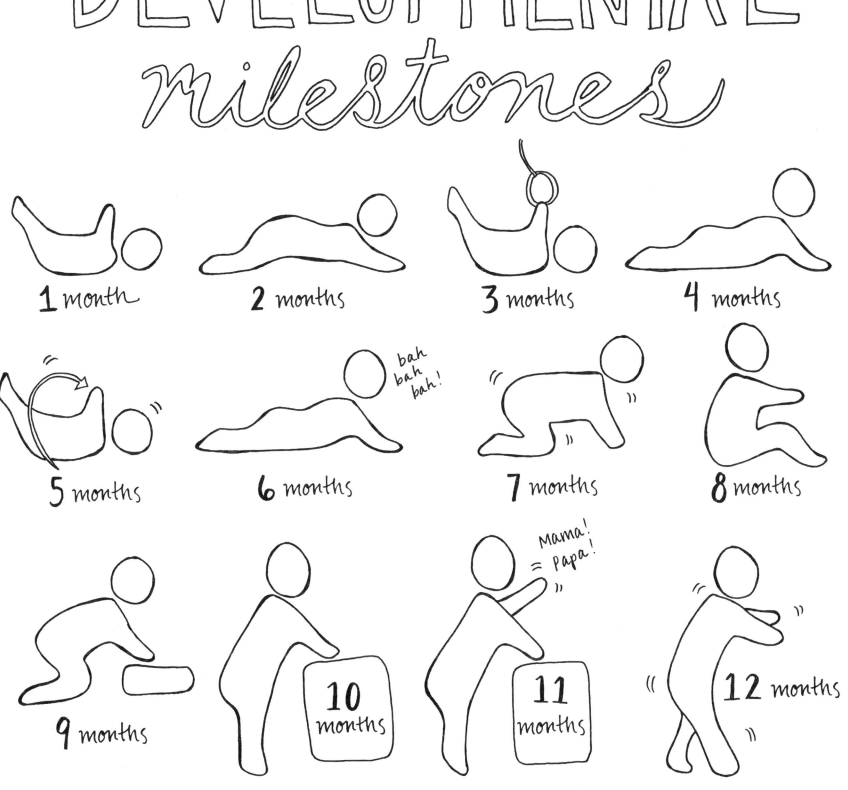

MADRE y PADRE

MOM mommy daddy

dada DAD

mama mere et pere

NANA GRANDAD

POP NANNY

POPPA MIMI

GRAMMY GRAMPS

GRANDMA POPS

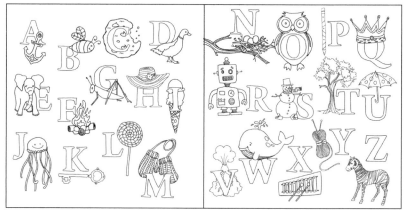

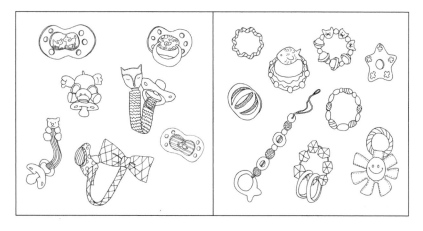

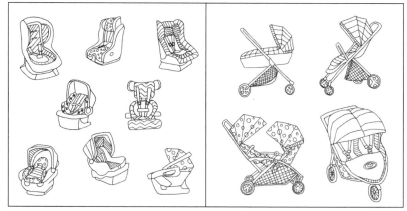

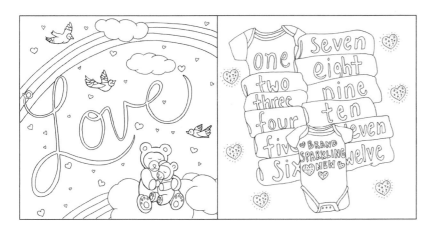

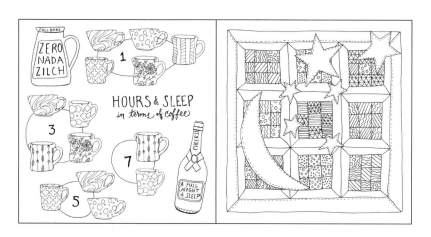

ZERO NADA ZILCH

HOURS of SLEEP
in terms of coffee

1

3

7

5

CHEERS!

A FULL NIGHT of SLEEP

...let her SLEEP
for when she wakes
SHE WILL MOVE
MOUNTAINS

LOVE YOU

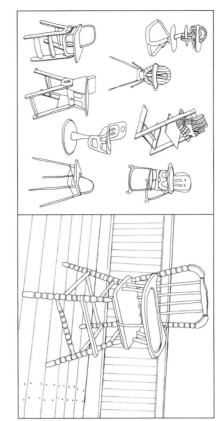

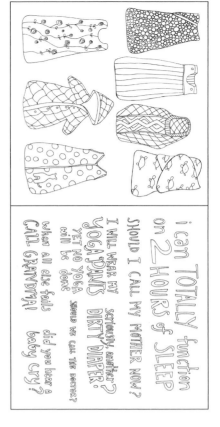

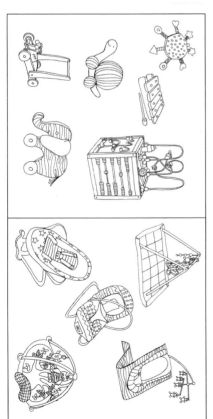

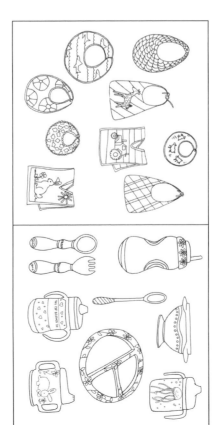

i can TOTALLY function on 2 HOURS of SLEEP

SHOULD I CALL MY MOTHER NOW?

I WILL WEAR MY YOGA PANTS

YET NO YOGA will be done

SERIOUSLY, another DIRTY DIAPER.

when all else fails CALL GRANDMA!

SHOULD we call THE DOCTOR?

did you hear a baby cry?

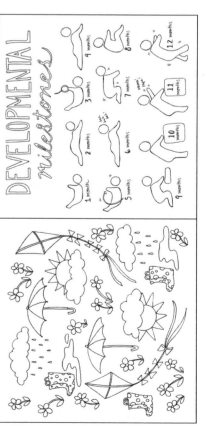